The Spur Book
of
Outdoor Photography

SPURBOOK VENTURE GUIDES

The Spur Book
of
Outdoor Photography

PETER McKENZIE

SPURBOOKS

SPURBOOKS
(a division of Holmes McDougall Ltd)
Allander House
137-141 Leith Walk
EDINBURGH EH6 8NS

ISBN 0 7157 2072 4

CONTENTS

AUTHOR'S PREFACE

The enjoyment that we obtain from outdoor activities derives from two areas. One is of a sensory nature and includes the views and details we see, the feel of sun and wind on our faces, the sounds of the breeze and running water and the aromas of fellside and woodland. The other is the feeling of achievement after we have successfully accomplished something that is physically demanding, whether this means a hike across moorland or an arduous rock climb.

Photography extends our enjoyment of outdoor activities through its ability to capture spectacular, beautiful and atmospheric scenes and through its more straightforward ability to record events and moments in time as narrative sequences. In addition to allowing us to re-live past experiences, both pictorial and narrative photography can help us to convey our outdoor adventures to others who were not with us at the time.

In writing this book, I have assumed that the reader is an outdoors person with an interest in photography rather than a photographer interested in outdoor activities.

With equipment available today, it is perfectly possible to combine outdoor activities with photography without the necessity of being so preoccupied with the technical requirements of the latter that your enjoyment of the former is impaired. Nevertheless, the art-craft of photography depends on mechanical and optical engineering, so some background working knowledge will help people produce better pictures.

Since many readers will be complete newcomers to photography, I have given some space to technical basics. This has been kept to a minimum and, if readers with some knowledge of the photographic process feel that certain areas are missing, this is simply because they are not relevant to the brief of the book.

Chapter 1

THE CAMERA

How it works

In its simplest form, the camera is a light-proof box. Light-sensitive material (a roll or sheet of film) is held flat inside at one end and a lens, which focuses the image-bearing light on the film, is fixed at the other. Controlling the amount of light in order to obtain an image of the correct density, the lens aperture is varied by an adjustable diaphragm and the duration of the exposure is set by a shutter. In taking the picture, the subject is selected and framed by means of a viewfinder or ground-glass screen.

The classic simple camera was the old Kodak Box Brownie. This had a single-glass, fixed-focus lens, keeping everything in focus from infinity to about six feet; a single speed shutter which could also be held open for long exposures; a fixed aperture and a pair of tiny, reflecting type viewfinders for horizontal or upright pictures.

The specification of the Brownie seems extremely limited by today's standards. It was successful, however, because people were not encouraged to use it in extreme situations. Nobody tried for close-ups, fast action shots or pictures in low light. The Brownie was for static or slow-moving objects, in good light. It brought photography to millions of people who could not afford the price, or did not want the complexities, of its more sophisticated contemporaries. The Box Brownie made a significant contribution to the world's photographic archives and its principle of operation, simplicity and portability, is equally valid today.

For that reason, descendants of the Brownie are in existence today. It is still possible to buy fixed-focus cameras with just one or two shutter speeds that will perform very well in appropriate conditions. They give superior results to the Brownie because their lenses are of higher quality and because better film material is available. They are even easier to use because they have eye-level viewfinders.

Most cameras available today allow you a considerable degree of control over the functions that affect the image. You can focus the lens, you can vary the shutter speed, and you can alter the size of the aperture. Indeed, you can now buy cameras that will carry out all these functions for you. This results in a paradoxical situation where the application of sophisticated technology has resulted in the ultimate simplicity of operation! However, the more functions you surrender irretrievably to the camera, the less creative control you have and, of course, you also become dependent on battery power. Many electronically-controlled and electrically-powered cameras become totally unusable without battery power. (Some have limited mechanical back-up operations in the event of battery failure.) So, once again, we arrive at the need for simplicity — especially in outdoors work.

Whatever type of camera you have, some knowledge of how it works will help you make better pictures.

Focus
In all cameras that are not of the fixed-focus type, the lens can be moved back and forth in relation to the film plane, in accordance with the distance of the subject, to control the sharpness of the image. Mechanically, this is achieved by helical focusing in most cameras: i.e. by turning a ring on the lens barrel. With simple cameras, you set the distance by estimation, using a scale or subject symbols on the lens. With *coupled-rangefinder* cameras, a split-image viewfinder system is linked to the focus control of the lens and a double image of the subject merges into one when it is in focus. *Single lens reflex* cameras divert the image from the taking lens to a viewfinder and focusing screen via a mirror which flips out of the way just before exposure. *Twin-lens reflexes* use a separate lens just above the taking lens to produce an image on a ground-glass screen: in this case via a fixed mirror.

Aperture
The aperture of a lens is varied in size by means of a diaphragm — a sort of mechanical version of the human eye. Individual apertures are sometimes called *stops*, from the early days of photography when small slides with varying sizes of aperture

were used to 'stop' excess light reaching the film. In dealing with modern stops, we come to one of the first pieces of mystique in photography.

The aperture range on modern lenses is an apparently arbitrary series of numbers that has no obvious logical sequence. On a typical 35mm camera, for example, the apertures on the standard lens might be marked as 1.8, 2.8, 4, 5.6, 8, 11, 16, 22. These f-numbers as they are called are internationally used. They are arrived at by dividing the focal length of the lens by the aperture. On a 50mm focal length lens, therefore, an aperture of f1.8 means that the diaphragm opening will be 27.7mm across, at f5.6 the opening will be 8.9mm, and so on.

Having learned this historical fact, it is advisable to put it to the back of your mind! The important thing is to know that the difference between each stop represents a halving (or doubling) of exposure and that the lower numbers mean wider apertures and vice versa: an aperture of f5.6 lets in twice as much light as f8 and half as much as f4.

Another important fact is the maximum aperture (the speed), of any lens, since this will let you know how effective it will be in low light conditions. Fast lenses, with a maximum aperture of f1.4 to f1.8 on the 35mm format and f2.8 on larger formats, are more expensive than slower ones because they are more complicated in design and construction. They are, however, not necessarily of better quality than slower lenses, i.e. ones with smaller maximum apertures.

Depth of Field

An important feature of the aperture setting is its effect on *depth of field*. Whatever distance you focus on, there will be a range on either side of that distance in which everything will be acceptably sharp. This range — the depth of field — extends one-third in front and two-thirds behind the object focused upon. All other conditions being constant, smaller apertures give greater depth of field and vice versa.

The Shutter

Two main types of shutter are used in modern cameras. One is incorporated into the lens and consists of a series of overlapping multiple blades that open and shut for the appropriate length of time. Speeds with these 'leaf' shutters, as they are

called, usually range from one second to a maximum of 1/500 second. They are most commonly used in fixed-lens cameras. Flash can be used with leaf shutters at all speeds.

The second type is built into the camera body and is known as a *focal-plane* shutter, since it operates close to the surface of the film. (Its efficiency depends on its nearness to the film.) Focal-plane shutters consist of two curtains — of cloth or metal — that chase each other across the film with a variable distance in between to control the time any part of the film is exposed to light. Top speeds of 1/1000 or even 1/2000 second are usual with focal-plane shutters. Because of their method of operation, however, they will not allow the use of flash at speeds shorter than 1/60 or 1/125 second.

Focal-plane shutters are most commonly used in 35mm interchangeable lens reflex cameras, where they permit the valuable cost-saving feature of systems where each lens does not need its own, built-in shutter.

Shutter speeds are marked on cameras as fractions of a second, in increments that represent a halving or doubling of exposure.

Lenses

Lenses fitted to most modern cameras tend to be quite complicated in design and construction. Apart from a series of glass elements, they also have to incorporate aperture and distance controls and, in some cases, a shutter.

These complications are necessary because simple lenses, while effective up to a point, exhibit six basic defects which degrade the image. Most can be eliminated simply by closing down several stops but there is really no point in having a fast lens if you cannot use the widest apertures now and again.

The total elimination of optical defects at maximum aperture is extremely difficult and prohibitively expensive, so even the finest lenses produce their best performance when closed down a couple of stops. A large maximum aperture is still valuable since it means that the best setting for maximum optical performance is also relatively fast and thus more useful in low light conditions.

Generally speaking, four is the minimum number of glass elements needed to produce a lens of useful quality. At the

Colour Film

Most people today want
outdoor world is, after al
also impart more informa

In line with the objectiv
so that photography does
to concentrate on one of

If you want prints for ca
the opportunity arises, you
keen on showing slides, you
undecided, it is worth bea
effectively, you need to buy
illuminated hand viewer.

If your requirement is fo
tional need for prints — or
made from transparencies
made from colour negative

With negative film, you c
want as often as you wan
transparency material, each
to make duplicates but it is b
the picture is special.

Negative film is highly
slightly tolerant of under-ex
cameras. Colour reversal f
exposure errors and so shou
that allow fine control of ap
conjunction with an exposu

Film Speed

Film of all types comes with
light, and this is known as its
expressed in ASA (America

Basically, films of around
125-200ASA are medium sp
fast.

Slow films are finer-grainec
films but they have less expos
tolerant of over- and under-

other end of the scale, some zoom lenses have up to fifteen elements to allow correction of optical defects at all magnifications.

Focal Length

The focal length of a lens is the distance of the focused image from the lens when it is set at infinity. It is this focal length which determines the size of the image on the film.

With most cameras, the lens designated as 'standard' has a focal length equivalent to the diagonal of the negative, since this is supposed to approximate more closely to the human field of view. On the 35mm format, this formula would give a length of 43mm. In practice, so-called standard lenses vary from 40mm to 58mm on single lens reflexes and 35mm to 40mm on fixed-lens rangefinder models. Longer focal lengths will give a larger image and shorter focal lengths a smaller one when used at the same camera-to-subject distance.

A true long-focus lens needs an extension from the camera equivalent to its focal length and this can lead to size and weight problems. Today, it has largely been replaced by the *telephoto* lens. This is of a special design which does not need so much extension. The same design principle has also been applied to short focal length (or wide angle) lenses so that these do not have to project so far into the camera body that they prevent the use of the mirror of reflex cameras.

Zoom lenses allow infinite variations in focal length between their longest and shortest settings, while keeping the subject in focus. They are easier to make in the longer focal length ranges, but wide-to-normal focal length zooms are also available.

Basically, camera film
base of triacetate or
grains that respond to
much exposure they
which is brought out a
fixing. Photographic ch
we need go no further

Film for amateur us
and-white negative ma
negative material for c
transparency) material

Black-and-White Film
Black-and-white film ha
began and was the only
tively recently. Most peo
up photography at an ea
when you took your film
and printing. If he was an
lot of valuable advice as

Today, with the tremen
is actually quite difficult
black-and-white film (ex
material, which can prod
mainly used by enthusiast
cessing and printing. To g
you really do need to hand
to an infinite degree of ma
and printing stages. While
from colour material, the
original black-and-white f

moderate enlargements and in projected slides, the difference is negligible.

At the moment, colour negative film is most commonly available in speeds of 100 and 400ASA. Because fast film permits the use of smaller apertures and fast shutter speeds, it gives a greater chance of success in terms of sharpness and in freezing action/eliminating camera shake. So it is my recommendation for outdoors use. An exception to this is in the case of 110 cameras, where the negative is so small that the grain of 400ASA film is apparent even at postcard-size enlargements. Unfortunately, some simple 110 cameras are prone to giving disappointing results because of camera shake at the slower shutter speeds needed with 100ASA film and this eliminates any advantage of finer grain. This problem does not occur with the more sophisticated 110 cameras, or in locations where the light is bright enough to allow shorter shutter speeds.

Colour transparency film is available in a very wide range of speeds, from 25ASA to 400ASA. Again, my choice would be 400ASA film, since it has the same operational advantages described above for negative material of that speed. Reversal film of 400ASA does have one disadvantage in that it is considerably more expensive than slower material. One solution is to use slower films (64 or 200ASA) in summer and then switch to 400ASA if you intend to do a lot of work outdoors in the winter months.

When buying transparency film for the first time, you should establish whether the price of the film includes processing or whether this will be an extra charge.

One final complication is that colour transparency film is available in natural and artificial light versions.

Artificial light produces a strong yellow cast on daylight-type reversal film. In outdoors photography, the only situation where this may cause problems is when you want to photograph floodlit buildings or street lights. There are three alternative solutions. You can accept the yellow cast; you can use a special conversion filter to neutralise it; or you can use film specially intended for artificial light.

Unless artificial-light photography is a special interest, the latter course is hardly worthwhile and even then the use of daylight film with a conversion filter will avoid the need to carry round extra types of film.

Care of Film

Under this heading, the most important task is not to allow film to become overheated or, even worse, to undergo a series of wide-ranging temperature changes. This can cause loss of speed and/or changes of colours to unnatural hues. Exposed and undeveloped film is more sensitive to this than unexposed film that is still in its original packing.

You should aim to have film processed as soon as possible after exposure. If this is not possible, keep it in a cool, dry place.

Film for amateur use has a long shelf life, but it is still wiser not to go on an important trip with film that has outlived the expiry date on the carton. If you have kept it in a cool place, such as a fridge, it may be safe but, if you have bought it at reduced price from a shop, you will have no way of knowing whether it has been kept for several months in some place like a sunlit shop window or near a radiator.

Chapter 3

BASIC TECHNIQUES

Before you can achieve high pictorial standards, you need to know how to use your equipment to take pictures that are satisfactory on a purely technical level.

The first task is to read the instructions supplied with your camera. Before loading a new camera with film, try some dry shooting to familiarise yourself with all the controls. Hold the camera firmly and develop an instinctive hold for both horizontal and upright shots.

Hold the camera level when shooting. Even the slightest tilt to one side becomes apparent on pictures, particularly when the horizon is included in the scene.

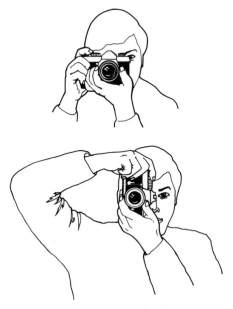

FIG. 1

HOLDING THE CAMERA FOR HORIZONTAL AND VERTICAL PICTURES

After you have taken a picture, make it a habit to wind on immediately to the next frame. This will increase your state of preparedness and also prevent accidental double exposure if your camera does not incorporate a device to prevent this automatically.

Make sure you know how to remove film from your camera. With cartridge-loading types, this is quite a foolproof process but care is needed with 35mm and rollfilm types. The former has to be rewound back into its cassette before you open the back of the camera. It should be wound fully into its cassette so that there is no possibility of you confusing an exposed film with an unexposed one.

If your camera is not a single-lens reflex, throw away the lens cap and replace it with a colourless filter to protect the lens. Otherwise you may well forget to remove it at a critical moment and so miss an important shot.

Focus carefully. If you want maximum depth of field, use as small an aperture as possible without this requiring a too-slow shutter speed that might cause camera shake. Some cameras have depth of field scales engraved around the focusing mark. You can maximise depth of field by placing the distance of your subject between these. If you are shooting at f22, for instance, and want to include as much as possible between yourself and infinity, you should set the infinity mark on the focusing barrel just inside the f22 mark on the depth of field scale. Everything between infinity and the opposite f22 mark on the scale will be in acceptable focus.

So far as depth of field is concerned, it is worth remembering that the further away the subject is from the camera, the greater is the depth of field and vice versa. Also, at equal lens-to-subject distances, wide-angle lenses have greater depth of field than telephotos. It is important to note that this is only true when the lens-to-subject distances are equal and the same f-stop is used in each case. If you take the same picture with lenses of different length and position yourself so that each produces an image of identical size, and if you use the same f-stop with each lens, the depth of field will be the same in every case. (The perspective would change, since this is influenced by camera-subject distance — see chapter 4).

To eliminate unsharpness caused by camera shake, you should always squeeze the shutter rather than stab at it.

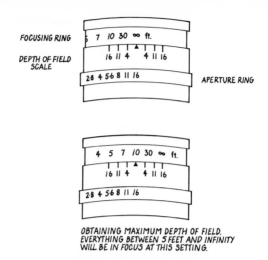

FOCUSING RING

DEPTH OF FIELD SCALE

APERTURE RING

7 10 30 ∞ ft.

16 11 4 4 11 16

2·8 4 5·6 8 11 16

4 5 7 10 30 ∞ ft.

16 11 4 4 11 16

2·8 4 5·6 8 11 16

OBTAINING MAXIMUM DEPTH OF FIELD.
EVERYTHING BETWEEN 5 FEET AND INFINITY
WILL BE IN FOCUS AT THIS SETTING.

FIG. 2

Ideally, for guaranteed shake-free pictures, you should use a shutter speed of 1/250 second. (This is particularly important in landscape work, where you need to record fine detail.) Otherwise, acceptable results can be achieved at speeds as long as 1/30 second, especially if high enlargements are not needed. In situations where you have no other choice, you can hand-hold at much lower speeds and it is often better to tolerate a little blur rather than lose a picture. Movement can be reduced if you brace yourself firmly against something and breathe out before squeezing the shutter.

Exposure
Set the correct shutter speed/aperture combination to give the right exposure. Note that there will be a number of correct settings since, for instance, if 1/60 second at f8 will admit the right amount of light, then 1/30 second at f11 will do the same, because you are giving twice the exposure in terms of time but halving the size of the aperture.

If you want maximum depth of field, you will set a small aperture which will require a relatively long shutter speed. If you want to freeze action, you will need to set a fast shutter speed which will call for a relatively large aperture, with a consequent reduction in depth of field.

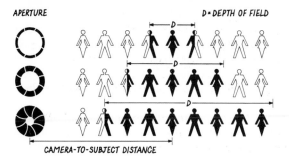

APERTURE D = DEPTH OF FIELD

CAMERA-TO-SUBJECT DISTANCE

HOW DEPTH OF FIELD INCREASES
WITH SMALLER APERTURES. FIG. 3

How the Camera 'Sees'

Having acquired the basic ability to take pictures that are in focus and correctly exposed, you need to cultivate an ability to 'see' like a camera, since the human eye and the camera lens behave quite differently.

Human vision actually encompasses a wide field of view: equivalent to an ultra-wide-angle lens, it is also selective, and this ability of the mind to concentrate on individual elements of a scene means that it acts like a telephoto lens. Human vision is also binocular and stereoscopic and so allows us to perceive things in three dimensions.

In addition to being capable of telephoto vision and to being selective in what it is observing, the brain can also be *selectively inattentive*. It can regard one object and, at the same time, deliberately disregard anything irrelevant that is also in the field of view.

The image recorded by the camera is strictly two-dimensional. Perspective will be affected by the position of the camera in relation to the subject. Wide-angle lenses will exaggerate perspective, telephoto lenses will compress it.

In addition, the angle of the film plane will affect perspective. The most common example of this is when tilting the camera back to take pictures of tall buildings. The vertical lines will seem to converge unnaturally, simply because the brain automatically compensates for the convergence whereas the camera cannot (unless it is of a special type).

The camera will also be faithful and impartial in what it records, so that your final picture may include a few empty beer cans which you had not noticed at the time. Or there may have been a tree in the background which you disregarded when you took an outdoor portrait but which appears to be growing straight out of your subject's head in the finished print.

None of these features of photography should be regarded as limitations. Rather, they can be used and manipulated to produce results that can be creative, dramatic and informative.

Practice

If you are taking up photography for the first time, you will naturally want to get in some practice with a new camera simply to establish that you know how to operate it (and to make sure that it is working properly). You should make this trial run before setting off on an important trip. To help you acquire an ability to see like a camera, try as many different subjects as possible with your first film: people individually and in groups, close-ups, buildings and landscapes, fast-moving subjects and slow-moving ones. Do not try anything too ambitious to start with, such as against-the-light shots: breaking rules can be done to greater effect after you have first learned them.

Get in Close

There is one technique, however, which is so important in almost all types of photography that it is worth emphasising from an early stage: *get in close to your subject.* Being too far away and so including too much irrelevant detail is the most common fault with beginners to photography. Tight framing at the taking stage (which is particularly necessary with slide film anyway) almost invariably produces more effective and pictorially striking results.

Chapter 4

MAKING PICTURES

The ability to produce photographs that are satisfactory in purely technical terms — the *taking* of pictures — will not automatically guarantee that they will be satisfactory in an aesthetic sense. The achievement of a degree of craftsmanship and a knowledge of how your camera will behave when pointed and operated in a certain way is only the starting point in the quest to produce pictures that communicate effectively: the *making* of pictures.

Composition

A great deal has been written about this subject but, basically, the objective in composition should be to produce a picture that is satisfying and self-contained. In photography, the key criteria are *simplicity* and *balance.*

Simplicity is achieved by excluding extraneous details and elements and by concentrating on the subject. Once again, this means getting in close. Where this is physically not possible, you can either change to a lens of longer focal length or seek an alternative viewpoint.

Balance can be obtained by following some simple primary rules of graphic composition. The main object of interest should be at one of the four points in a frame that are one-third in from both edges and it should be balanced by an opposing item of secondary interest. This secondary element prevents the eye from wandering out of, or around, the picture but it should not be so large as to result in total symmetry.

Never break the picture into two equal parts. If the horizon is in the scene, it should be one-third in from either the top of the bottom.

Vertical components, such as tall trees, add to a feeling of height and can be emphasised further by using a vertical format (or by 'cropping', i.e. only printing part of the negative, if your camera takes square pictures). Horizontal lines produce a feeling of breadth but should not take the eye right out of the picture. Strongly converging lines give an impression of depth, which can be accentuated even further through the

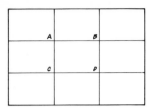

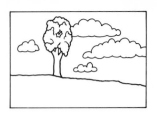

RULE OF THIRDS.
MAIN ELEMENT OF THE PICTURE
SHOULD BE AT A,B,C OR D.

RULE OF THIRDS.
MAIN ITEM OF INTEREST, THE TREE
IS ONE-THIRD INTO THE SCENE
AND GROUND CONTOUR IS ONE-THIRD IN
FROM THE BASE OF THE FRAME.

FIG. 4

VIEWPOINT

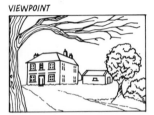

USING FOREGROUND OBJECTS
TO FRAME THE SUBJECT.

FIG. 5

inclusion of some object like a rock, plant or gatepost in the near foreground.

The elements of your pictures can also take circular, rectangular or triangular shapes. The triangle is the strongest, as in the typical head-and-shoulders portrait.

The hue of objects in colour photography also needs to be taken into account in composition. Simplicity is again desirable. A riot of different colours can easily look messy and confusing. Keep your colour pictures simple and effective by using large areas of single colour or by using subtle, muted shades where, while colour is important to the scene, the effect is almost monochromatic.

Colour can also be used to achieve balance. A small red object in a picture can provide balance to a much larger area made up of less aggressive colours, such as blue and green.

Pictures should also be self-contained. We have noted that the eye should not be led out of the scene but rather led in and

then kept there. Where you cannot control your subject, you should move about to find the best viewpoint. You can also use framing devices, like trees, to contain the main area of interest but you should not include elements that come into the scene without visible means of support, like dangling branches.

Perspective
Perspective is defined in the Concise Oxford Dictionary as 'the art of delineating solid objects on plane surface so as to give the same impression of relative positions, magnitudes, etc, as the actual objects do when viewed from a particular point'.

Wide angle lenses and telephoto lenses exaggerate perspective in different ways; the former because their wide angle of view and great depth of field means that they need to be used closer to your subject and, the nearer things are to the camera, the larger they appear in proportion to things further away. Telephoto lenses compress objects into the same plane and make distant and middle-distance object appear almost the same size. The features of lenses of different focal lengths mean that you can either record perspective accurately or you can alter it to emphasise some aspect of the scene to produce a striking pictorial effect.

The focal length which gives the most pleasing perspective (on the 35mm format) is something around 85mm-105mm. This moderate telephoto is very useful for landscape work and portraiture.

Whatever lens you use, perspective in photographs results exclusively from the distance between the camera and the subject. If you took the same scene with wide angle, standard and telephoto lenses from the same position and produced same-size enlargements of the *subject* from each negative, the perspective would be identical in each.

Conversely, if you used wide angle, normal and telephoto lenses to photograph something like a tree at the foot of a hill and positioned yourself so that the tree was the same size on all three negatives, the apparent size of the hill would change: larger with the telephoto and smaller with the wide angle. This is because the background object — the hill — is less affected by the change in distance than the foreground one.

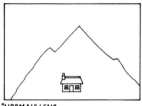

"NORMAL" LENS

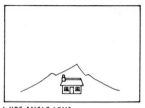

WIDE ANGLE LENS

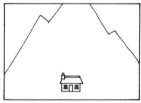

TELE LENS

USE OF THREE DIFFERENT FOCAL LENGTH LENSES
AND ALTERING CAMERA POSITION WITH EACH ONE
TO KEEP THE HOUSE THE SAME SIZE.
NOTE CHANGES IN PERSPECTIVE.

FIG. 6

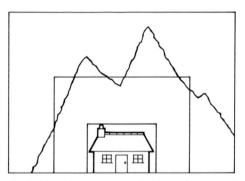

CONTENT AND FIELD OF VIEW WITH WIDE ANGLE, "NORMAL" AND TELE LENSES
WHEN USED FROM THE SAME CAMERA POSITION.

FIG. 7

Viewpoint

The selection of camera angle plays an important part in pictorial photography. It controls the contents of your pictures, their relationship to each other and to the direction of the light.

With distant landscapes, where you cannot move the subject, you can move your camera position to get the best effect. You can choose a low viewpoint to include a foreground object or you can position yourself so that the distant scene is contained by something in the foreground, such as an arch.

When photographing people, you can position them to take the best advantage of the direction of the light and you can

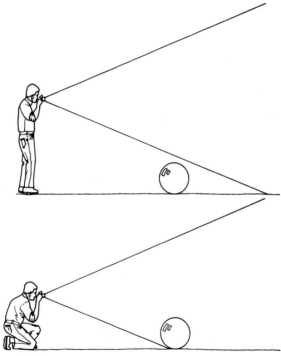

CHANGING THE VIEWPOINT ONLY SLIGHTLY CAN ALTER THE CONTENTS AND COMPOSITION OF A PICTURE.

FIG. 8

locate them in front of a specific background. You can photograph them from a kneeling position or climb a tree or rock to obtain a more unusual view.

Whenever you see some scene that you think is worth a photograph, take some time to consider your surroundings and try to find the best viewpoint.

Creative Use of Exposure Controls

As we noted in the previous chapter, in any given picture situation, there will be several possible aperture/shutter speed combinations that will admit the correct amount of light. Creatively, you can enhance your pictures by giving priority to the aperture or the shutter speed.

The aperture can be used to control the image in other ways than simply permitting short shutter speeds to eliminate camera shake. For outdoor portraits, the small depth of field produced by a large aperture will blur the background sufficiently to make the subject stand out in sharp relief and to eliminate any background detail that might cause distraction.

Alternatively, you may want maximum depth of field: perhaps to include a near foreground object to give scale to a distant landscape. In this case, you would use the smallest possible aperture.

Shutter speeds can also be given priority for certain situations. An obvious case is the need to freeze motion and reveal new pictures not apparent to the human eye, such as flying birds and other fast-moving animals. At the other extreme, slow speeds can be used to emphasise motion. Outdoors, one of the most common applications of this technique is with running water. Speeds that freeze the flow can cause unnaturally static results, while exposures that cause a little blur — 1/30 second and longer — more effectively recreate the original scene.

Getting the Best from an Exposure Meter

A normal exposure meter — either built into your camera or a separate, hand-held model — will tell you the intensity of the light reflected from the scene or subject you are photographing and will advise you of the correct range of aperture/ shutter speed settings.

Nearly all exposure meters intended for amateur use are also calibrated for scenes of 'average' brightness and, left to their own devices, will produce acceptable results 90% of the time simply because most scenes do contain equal amounts of light and dark areas.

However, *meters do not make decisions.* They only respond in one way in that they only give the correct exposure if the scene is a medium shade of grey. With scenes that are predominantly light, a meter will continue to behave as though they are grey, and so cause underexposure. With scenes that are overall dark, it will cause overexposure.

This means that you should give shots like snow scenes about two stops *more* than the meter indicates while subjects like dark woods or caves should have one or two stops *less*. At first, this may seem paradoxical but underexposure of snow will make it appear grey instead of white (as the unthinking meter intends) while overexposure of dark locations will cause them to appear lighter than they actually appeared to you.

Similarly, if you are photographing a traditional landscape that has a sky with a lot of white clouds and you intend to place the horizon one-third up from the bottom of the picture, you will need to give about one stop extra exposure to compensate for the underexposure that the meter will suggest because of the clouds. Alternatively, you can take a reading with the horizon line running along the centre of the picture (if you are using a built-in meter) and then use that setting when taking the actual picture. Hand-held meters in this situation should be used to take readings from the sky and then the foreground, with the actual setting being half-way between the two.

Some hand-held meters will also take *incident light* readings. A diffuser is fitted over the light cell and the reading is taken from the subject position, *with the meter pointed at the camera.* Incident light readings measure the amount of light falling *on* the subject, as distinct from light reflected *by* the subject. This method is particularly suitable for subjects of high contrast when using transparency film. It can also be used for distant landscapes if the light falling on the camera position is the same as that illuminating the whole landscape. With incident light readings, it is not necessary to make special compensating adjustments for scenes that are overall light or dark.

One other simple method of obtaining good results from a reflected-light meter is to take the reading from the palm of your hand (taking care to fill the meter's field of view with your hand but also not to let its shadow block the light) and then giving one stop extra exposure. This can also be done using a built-in meter simply by moving the camera closer to your hand when taking the reading.

In some circumstances, there may be several different exposures that are capable of giving good pictorial results. If in doubt, bracket important shots by making additional exposures at a half stop under and a whole stop over.

Presentation
After you have been out and about with your camera, presentation of your pictures when they return from processing and printing is important, particularly in narrative terms. If you are giving an account of a trip, make sure your story has a definite thread of continuity running through it, with a beginning, middle and ending. In addition, it is helpful to have a balanced mixture of long, middle-distance and close shots to provide relief and contrast and to sustain the interest of an audience.

In presenting prints, as opposed to transparencies, look to see where 'cropping' to different shapes and formats can help improve the picture. Slides can be cropped but this is a fiddly business and it is better to concentrate on good composition at the taking stage.

Chapter 5

TRAVEL TECHNIQUES

When photography is a supplement to outdoor activities, it is important to combine the maximum of photographic capability with the maximum of inconvenience in carrying equipment. Taking portability as the only criterion, it is possible to accomplish a great deal with a single camera/lens combination. Certainly, if you are experimenting with photography for the first time, you should limit your initial investment to one camera. Later, if your interest develops, you may wish to increase your equipment, and some ideas along these lines are discussed in chapter 9. Here, we shall limit ourselves to the logistics of photography in association with outdoor activities.

The first and most important rule is to have your camera ready for use at all times. There is no point in having it at the bottom of a rucksack; or even at the top, for that matter, if you have to undo straps to get at it. By the time you are ready, the picture opportunity will probably have disappeared.

Spare film and any odd accessories will, of course, need to be carried separately. Jacket pockets can be used. Rucksacks that have separate outer pockets are also useful, as are those that incorporate a separate compartment in the base.

On most occasions, you will be able to carry the camera slung around your neck in its ever-ready case. Alternatively, if it is small enough, you can keep it in a handy pocket. In this case it is probably better to dispense with any carrying strap since it will only get tangled up in something. The soft zippered pouches that are supplied with some cameras can also be a nuisance in that they are fiddly to open and close.

A camera slung around the neck and hanging in front will bounce and sway around a lot and this can become extremely irritating. The best way is to sling it diagonally so that it hangs in front and to one side. If you are rock climbing, you can shorten the strap enough for the camera to be held in place behind, just below the shoulder blade, where it should not impede your movements.

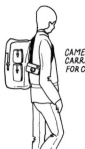

CAMERA ON SHORT STRAP
CARRIED DIAGONALLY
FOR CLIMBING.

CAMERA CARRIED DIAGONALLY
AND IN FRONT FOR WALKING.

FIG. 9

Cycling with a camera presents different problems. You can devise some sort of attachment on the cycle itself but there is some risk of the camera being stolen if you leave the bike unattended and forget to take it with you. One solution is to make a quick-release hitch for attaching the camera to your belt, just above the hip, with the main strap worn diagonally. As an alternative, camera chest harnesses are available.

If you are camping, keep the camera near the entrance to your tent. Some of the best landscape scenes present themselves when you poke your head out of the tent for the first time in the early morning but the dawn light changes rapidly in quality and angle as the sun rises, so you need to be quick. Also, of course, you do not want to disturb your tent-mate by fumbling about with your gear in the semi-darkness.

In addition to keeping your camera available for use at all times, you should also have it set so that you require little or no final adjustment for any 'snatch shot' opportunities that may occur. To obtain maximum depth of field, you should set as small an aperture as possible in conjunction with a shutter speed that will permit hand-held shooting without the risk of camera shake.

Protection

Protecting cameras from physical damage demands some sort of compromise in the sense that, if you are over-protective, you will probably not be able to get at your camera quickly enough when you need it. Yet you do have to take more care in outdoor activities since there is nothing more frustrating than being in the middle of a lengthy trip with a broken camera.

The most effective method is to keep your camera in its ever-ready case; but not if this is a soft zippered pouch of the type supplied with many compacts. These give no protection from shock and are merely a nuisance to open and close.

When travelling by car or bus, cushion your camera from vibration by carrying it on your knee or on an upholstered seat, never in a glove or luggage compartment or parcel shelf.

If you have any fragile secondary items that you do not need access to so quickly, such as interchangeable lenses or another camera, adequate protection can be obtained by placing them in a polythene bag to keep out any dust and then wrapping them in a towel or spare sweater. The bundle can then be stowed in a rucksack; preferably at the top for ease of access and also in case anything liquid you may be carrying escapes from its container.

The front elements of camera lenses have a relatively delicate coating designed to improve light transmission. This should be protected by a good quality clear glass filter — for ultra-violet or haze — that can be left in place all the time whatever type of film you may be using. Never touch the lens with your fingers. If it gets dusty, roll a piece of clean cloth into a narrow tube and brush it off very gently.

Protection from Rain

In moderate rain, the standard ever-ready case should provide adequate protection. In persistent or heavy rain, a cagoule with a 'kangaroo pouch' front pocket provides both protection and reasonable accessibility. Most of these pockets are large enough to hold cameras up to single-lens reflex size. The camera strap should be left around your neck.

If you are in a situation where you want to go on shooting for some time in rain, you can make a good protective cover out of kitchen cling-foil. It should be wrapped loosely over the whole

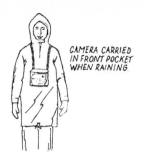

CAMERA CARRIED
IN FRONT POCKET
WHEN RAINING.

FIG. 10

camera to permit operation of the controls and stretched tightly over the lens to remove any wrinkles and prevent too much degradation of the image.

The ultimate in wet-weather protection for conventional cameras is a case designed to allow its use underwater. The rigid metal ones are simply not practicable for general outdoors use but some types are available in the form of a thick plastic bag with a glove insert to allow operation of the controls and with plate glass windows for the lens and viewfinder. If you intend to do a lot of winter trips, or if sailing in small boats is one of your outdoor activities, this could be the solution. Alternatively, when choosing a camera, you could consider one of the increasing number of conventional-looking cameras that are either fully waterproofed or weatherproofed to varying standards (see chapter 9).

Protection from Heat
Hot weather is bad news for cameras and film. A modern camera (most of which are all-black and so even more prone to absorb heat) will heat up rapidly if it is left in direct sunshine for any length of time.

When travelling, the most hazardous locations are car interiors. Wrapping cameras in something like a towel will give adequate insulation.

If you are going somewhere hot for a long time, it is best to store film in the main compartment of a fridge. If you do this, you need to allow it a couple of hours to warm up before unwrapping it in order to prevent condensation forming on the emulsion. After exposure, film should be returned to the fridge if it cannot be processed immediately.

Protection from Cold

In very cold weather, the mechanism of cameras can be affected as the lubricants thicken, although most modern makes are not really subject to this problem. Film becomes brittle and so is liable to break when being wound or rewound. It can also become stiff enough to cut your fingers. In dry cold, sparks of static electricity may leave marks on film.

So, in cold conditions, keep your camera and film as warm as possible but not so warm that condensation will occur when you take it outside. Underneath the outer layer of your clothing is the best place. Indoors, or in tents, leave equipment in a warm place but not too close to lamps or fires.

Protection from Sand and Dust

Wind-borne sand and dust are arch-enemies of outdoor photographers. They can clog up camera mechanisms and penetrate to the inside of the body where they may settle on the film or become trapped in a place where they cause long scratches on negatives.

A permanently-attached clear glass filter will protect the front element of the lens. To keep material out of the film chamber when changing film, put the camera in a clear polythene bag large enough to allow you to put both hands in and open the back. If you keep the closed end to the wind, it should keep out any flying dust.

Other precautions are fairly elementary. Do not stand downwind of someone shaking out a towel on a beach; or someone digging a hole in dry earth. Try to avoid putting your camera down anywhere that is dusty. Even in calm conditions there can be currents of air that move dust and sand along a few inches above the ground.

Protection from X-Rays

If you are travelling abroad by air, it is best to assume that there will be no way of protecting films from X-rays used in surveillance devices by airport security staff. This is because there is conflicting and unresolved evidence as to how much these machines cause fogging on unprocessed film. Some machines do not use X-rays but it is not always possible to establish the precise type, especially where differences of lan-

guage make conversation difficult. A security guard may answer 'yes' or 'no' to your question depending on which reply he feels will make you move on more quickly! The only safe method is to carry film on your person and request a personal inspection. In some cases, even this will not be acceptable and, if your film is really precious, you should consider having it processed locally before returning if there is time and if the appropriate facilities are available.

Insurance

Insure all your equipment and have the value of each item reviewed each year, increasing the cover where necessary. If you are travelling overseas, check that the policy covers travel to your destination: some countries may be excluded and extra premiums will be needed.

Chapter 6

LANDSCAPES

Classical landscapes are a plentiful and natural subject for the outdoor photographer. Landscape work is one of the most widely practised photographic specialities and its results surround us everywhere: in advertisements, on postcards, chocolate boxes and Christmas cards, and in books and magazines. This large volume of good landscape work is misleading in a way since it is one of the most difficult areas in which to achieve good results.

The most important task is simply to be in the right place at the right time. This is because the mood of a landscape is forever changing according to the quality and direction of the light, the number and type of clouds and the overall nature of the weather. A sombre, stormy vista that is dark and colourless can be transformed for an instant if the sun bursts through the clouds to highlight some distant feature.

Obviously, if your main objective is to accomplish a hike, you cannot hang about at a likely spot waiting for the conditions to change. If a particular scene does fascinate you, you may have to return many times before you obtain the picture you want.

However, suitable landscape opportunities will present themselves in the course of most outdoor activities. Once you are in the right place at the right time, you have to co-ordinate the elements of composition, viewpoint and exposure, as discussed in chapter 4.

Landscape Composition

Recalling the rule of thirds: if the horizon is in the picture, should it be one-third into the frame from the top or the bottom? The answer will depend on whether the ground itself or the skyscape is the chief interest.

In a picture which extends to the far horizon, it is effective to have a recognisable object in the foreground, such as a rock, a shrub or a person. This will give scale and a feeling of depth to the picture. It will also let the viewer relate to the scene and feel closer to the spot where you took the photograph. The

WHERE THE HORIZON IS IN A PICTURE
IT CAN BE ONE-THIRD IN FROM THE TOP....

.... OR FROM THE BOTTOM.

FIG. 11

foreground object should not be too close, or it will dominate rather than accentuate the picture.

The colours in a colour photograph will also have predictable effects. Cool shades like blue and green give an impression of distance while the hot colours tend to stand out of the picture. For this reason, it can be useful to have something red in the picture. This need not necessarily be a foreground object: a discreet patch of red or orange at any distance can help the composition if it is in the right spot.

In colour photography, even more than in black-and-white, strong and simple shapes are the most effective. Too much detail and too great a variety of hues will give messy results. While you cannot follow the rule of getting in close in broad landscape work, you can achieve the same effect by choosing the right viewpoint, by changing to a lens of longer focal length or by means of framing devices such as trees.

The use of a natural frame to enclose a distant scene is specially useful if you are limited to a single lens of moderately wide focal length, such as that fitted to many 35mm compact and rangefinder cameras. For distant landscapes, the field of view of these lenses is a little too wide and results can look disappointingly flat and empty. Conversely, wide angle lenses are very effective in encompassing foreground objects and the distant view and their relatively great depth of field means that everything can be kept in focus. Results can occasionally be further improved by using wide angle lenses with the camera in the upright, rather than horizontal position.

If you have a camera with interchangeable lenses, you will probably find that the most pleasing results in landscape work are achieved with a moderate telephoto. This focal length

makes it easy to keep unwanted detail out of the frame and it also produces an attractive perspective.

Whatever focal length lens you use, you can make the most of it by choosing the most effective viewpoint. You can shoot from a kneeling or prone position or you can climb up a tree or boulder, tilting your camera up or down to control picture content and perspective.

The Light

The most important single influence in landscape photography is the lighting, both in terms of direction and quality. In turn, these features are influenced by the time of day.

In most latitudes, the sun is so high between 11am and 1pm that there are few shadow areas and the landscape will appear flat and uninteresting. Near the Equator, this flat-light period starts even earlier and finishes later, while it is shorter the nearer you approach the poles.

In the morning and evening, the sun will be at a low angle and so produce dramatic shadows. The colour of the light is redder at these times because it is passing through a greater thickness of atmosphere and this filters out most of the blue end of the spectrum.

The rising and setting sun produces a rapidly changing sequence of colour changes that provide a great many picture opportunities in a short space of time.

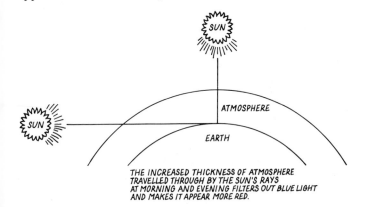

THE INCREASED THICKNESS OF ATMOSPHERE
TRAVELLED THROUGH BY THE SUN'S RAYS
AT MORNING AND EVENING FILTERS OUT BLUE LIGHT
AND MAKES IT APPEAR MORE RED.

FIG. 12

Pictures taken against the light can be particularly effective at dawn and dusk. In these situations, the rim of the sun's disc can be allowed to flare gently from behind a tree or ridge without being so bright that it results in underexposure of the foreground. (Unless, of course, you want a silhouette effect, when you should expose for the sun only.)

Seascapes and Shorescapes

In pictures made up mainly of sea and sky you have absolute simplicity of picture components and some very striking scenes composed of just light, shade and few basic shapes are possible. Alternatively, you can use boats, rocks, seaweed and driftwood to provide accent and balance.

As with shots of the sun over land, several picture opportunities will occur as the sun rises or sets over the sea, changing quickly in both size and colour.

Panoramas

Panoramic views are comparatively simple to produce with conventional cameras. All you need to do is rotate the camera across the scene and take photographs as you turn, with a suitable overlap between frames to allow joining of the finished pictures later. For the best results, it is necessary to hold the camera perfectly upright for each shot, since the slightest tilt will make the horizon curve up or down when they are joined together. Long focal length lenses are more effective than shorter ones and results are easier to prepare and present with prints than with transparencies. If you become addicted to panoramas, you can obtain special swivelling tripod heads which incorporate a spirit level and graduations for accurate overlapping.

Topographical Photography

Since outdoor activities are your main interest, do not hold back from taking a picture of a particular scene simply because you feel it will not photograph well. Some pictures are useful as record shots. They can be used in narrative sequences and also to give information to people who may be planning a trip to the same area.

Colour or Black-and-White?

Colour will be the medium used by almost all outdoor photographers. Nevertheless, landscape work, together with architectural work, is one area where black-and-white can occasionally be more effective. Some scenes that are made up of simple, strong shapes and *textures,* like outcrops of rock on a hillside, may work better in black-and-white, particularly if the scene contains a lot of colour that is not contributing to the picture. Here, colour photography might merely be distracting. Black-and-white minimises tonal differences and so leaves the emphasis on the textures and shapes that make the scene.

Conversely, some scenes that are monochromatic in real life can look better if reproduced in colour — either soft and muted or all one tone, with perhaps just a single patch of contrasting bright colour to enliven the scene.

The great difficulty of trying to work with both colour and black-and-white is that of changing your attitude of mind from one to the other. It is really much easier to concentrate on achieving good results with just one type of film.

Exposure for Landscapes

For distant landscapes and shorescapes, you should give one stop more than that indicated by the meter. For bright seascapes and snow scenes, two extra stops will be needed.

Capturing the Atmosphere

If you arrive at a dramatic location such as a spectacular waterfall, you will experience the scene as an *event* which touches upon all your senses. You will see the waterfall, you will hear it and you may feel its spray on your face, together with the sun and any breeze that might be blowing.

Still photography can go a very long way towards re-creating the original atmosphere if you concentrate on the three basic requirements of pictorial photography:

COMPOSITION — keep it simple and balanced.
VIEWPOINT — find the best angle/perspective.
EXPOSURE — the correct settings that are also appropriate to the effect you wish to emphasise.

Chapter 7

PEOPLE OUTDOORS

In the popular newspaper world, it is a rule that virtually all photographs should have people in them. The need for a human interest element is not so strong in outdoor photography: in some situations, such as certain landscape shots, their presence can be undesirable, but as most outdoor activities are shared with others, people make good subjects for both pictorial and narrative photography.

Posed Pictures
People involved in outdoor activities are normally relaxed and enjoying themselves. This, together with the fact that you, the photographer, will probably be a close friend or relative, means that you should be able to obtain posed shots that will not look contrived or awkward.

Indeed, do not despise the traditional, tourist-type shot of groups posed in front of a landscape or building. People like to have some record of their having visited a place and this is a perfectly legitimate way of fulfilling this desire. If you want a classic landscape or architectural picture without any people, all you have to do is take your group shot first and then ask the human element to move out of the way.

The ability to pose people and to position them carefully in any particular location means that you can control the composition of your pictures quite accurately. One element that is not controllable is the light in outdoor photography, however, so co-ordination of background, subject and the direction of the light should start with priority being given to the latter.

The least suitable light is that from a high sun, which causes unnatural shadows on faces. Direct sunshine can cause problems at other times, since it makes people screw their eyes up. The most comfortable lighting is a bright haze. Otherwise, you should manoeuvre your subjects into semi-shade.

If you are taking a record shot and want the background to be in focus, be on the look out for anything that might spoil the composition of the picture.

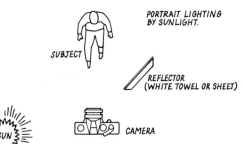

PORTRAIT LIGHTING
BY SUNLIGHT.

SUBJECT

REFLECTOR
(WHITE TOWEL OR SHEET)

SUN

CAMERA

FIG. 13

Candid Photography

Candid photography is often associated with pictures of people caught in awkward positions or with peculiar facial expressions. In fact, candid techniques can be used to produce very attractive pictures.

Basically, in addition to making sure that your subject is completely unaware that he or she is being photographed, you should also aim to ensure that they did not know they were a subject until you show them the finished print later.

Naturally, this is not all that easy, since you have to position yourself in relation to your subject so that the lighting and background are satisfactory without giving the game away by having your camera aimed at them while you do this. The technique is to prefocus your camera, set the aperture for maximum depth of field, wait until your subject's attention is diverted away from you and then aim, shoot and lower the camera in one smooth action. Do not stand stiffly with the camera at eye level even for a single instant since this stance may come within your subject's peripheral vision and alert him or her to your intentions.

It is possible to use the technique of calling out to your subjects so that they look towards you just as you take the picture. This results in a fair degree of spontaneity but also establishes you as a candid enthusiast and people will soon become wary of you.

43

Telephoto lenses would at first seem to be very useful for candid work but they do have certain disadvantages. They flatten perspective and so give an unnatural sort of result. They are often difficult to hold steady for any length of time so you need a faster shutter speed to eliminate camera shake. Yet this is not always possible since, at the same time, you will need a small aperture to obtain reasonable depth of field.

Telephotos can be used when no other method is possible but you need a really long one — 200mm or more on the 35mm format — to operate undetected.

Moderate telephotos are ideal for candid work. Wide angle lenses are not so satisfactory in that you cannot get close enough for good results without being detected, but they do have one useful feature. Their wide field of view means that you can use them to take pictures from waist level, aiming by guesswork and pretending to be interested in something else. Their relatively extensive depth of field will help ensure that your subject is in focus. With practice, you can use this technique when on the move, aiming the camera sideways where necessary. Physically, this is easiest with small compact cameras that can be held and operated with one hand. There will probably be some tilting of the subject on the negative but this can be corrected by selective enlargement if required.

CAMERA HELD AND OPERATED
BY THE SIDE WITH ONE HAND
FOR CANDID PHOTOGRAPHY.

FIG. 14

Outdoor Portraits

Outdoor locations are ideal for both formal and informal portraits. Your subject should be relaxed and comfortable and in a position where the sun does not cause deep shadows or squinting.

Diffuse lighting is best. If the sun if fairly bright, it should be coming towards the subject from one side and slightly in front. If it still causes deep shadows, you can fill them in adequately by getting someone to hold a white object, such as a towel, as a reflector.

Background is important and it can be controlled by careful choice of viewpoint. Ideally, it should be homogeneous and not distracting. A blue or cloudy sky is sufficiently neutral. Alternatively, you can use something like a dry stone wall or a patch of shrubbery. By setting a wide aperture, you can throw this type of background out of focus so that your subject appears to stand out more sharply. You should avoid straight lines in the background, such as the horizon or a line of trees, and anything that will divide the picture up into segments.

Use of Flash

Outdoor portraiture is one area where flash has some value. You can use it to fill in dark areas instead of a reflector or you can use it to obtain particularly pleasing portraits taken against the light. For those, you place your subject with his or her head directly between the sun and the camera, take an exposure reading from the camera position, open up the aperture by one stop (or use the next slowest shutter speed) and then take the picture, using flash. Note that you increase exposure by *one* stop, not the two stops that you would need if not using flash in this situation, and that you do not take into account the flash-to-subject distance. This technique can really only be used with small flash units, or those built into some cameras, and it works best at a distance of six to eight feet. It is not practicable with very powerful units, or types that operate automatically.

Pictorially, the effect should be something like a halo, as the sun shines round the face from behind, with the flash providing just enough light to illuminate the face without being so bright that it produces an unnatural result.

People in Landscapes

As noted in the previous chapter, people can be used to provide scale and foreground interest in landscape work.

When using this technique, do not have people too close to the camera or they will become the dominant feature in the picture. One of the best positions is low down and about one-third in from the edge of the frame to provide a balance to the main feature. They should not be looking directly into the camera since this will also increase their dominance of the scene. In colour shots of distant views, people with red rucksacks or cagoules can provide that useful colour contrast to add depth.

People at Work

Finally, do not overlook the documentary aspect. A few shots of people map-reading, cooking, washing, shaving and putting up tents will make any picture story more complete and interesting.

Do remember, however, that you and your companions' prime objective is enjoyment of the great outdoors, so do not impose your photography on people. Resist any temptation to poke your camera at friends all the time, or to make them pose when they are not in the right mood. Do not make everybody stop on a hike while you wait for the sun to come from behind a cloud. Instead, integrate your photography smoothly with the rest of your activities. The best praise for an outdoor photographer is when somebody says afterwards, admiringly: 'I didn't know you had taken *that* picture!'

Chapter 8

OUTDOOR SPECIALITIES

Opportunities for photographic specialities are numerous in outdoor situations and it is quite possible to pursue one or more without taking too much time off from your other activities.

Plants

Plants of all kinds are a major part of the outdoor scene and you do not need any special equipment to enable you to photograph them effectively. The standard lens of most cameras will focus to less than two feet and this is perfectly adequate for individual blooms.

For maximum impact, use a wide aperture to throw the background out of focus and so make the specimen stand out in sharp relief. Try a few shots against the light: this can produce particularly attractive results when photographing specimens with translucent petals. In locations where the background is untidy, you can isolate the subject by placing a sheet of coloured card behind it. The most useful all-round colour for such a card is mid-to-light blue, although if you are keen on special effects, any colour will do, depending on the shade of the flower.

Large areas of flowers look attractive in real life but may turn out disappointingly when reproduced on film. If you are somewhere like a well-known public garden, it is better to take one picture of the overall scene to identify the location and then get in close, concentrating on individual specimens and tight groups of flowers.

Some flowers are so small that you really need to get in closer than the standard lens will allow. In this situation, you need a close-up facility.

Close-ups

The simplest and most portable close-up device is a single element lens which is attached to the front of your camera lens in the same way as a filter. If you have a single-lens reflex, you will be able to focus and frame the subject with complete

accuracy. With other types of camera, you will need to measure the distance accurately to obtain the correct focus setting. This can be done by means of a string or chain of the correct length attached to the camera or, alternatively, by making a wire frame that can be fitted into the accessory shoe or tripod screw and which extends forward of the camera to enclose the subject at the correct distance, in a rectangle equivalent to the format of the negative. Such a frame can also be formed so that it corrects for parallax error, which otherwise will cause the image to be displaced at short distances because of the space between the viewfinder and the lens.

Close-up lenses come in various strengths termed *dioptres*. These are based on the focal length of the close-up lens in metres. So a 1-dioptre lens has a focal length and a closest focusing distance of one metre when the camera lens is set at infinity.

An alternative close-up technique for users of single-lens reflexes is the *tele-converter*. While this device doubles the focal length of any lens, it does not double the minimum focusing distance and so in effect halves it.

Lighting the subject can be a problem with close-ups. Flash can be used but will need to be reduced by means of a couple of layers of white handerchief. Alternatively, a reflector can be improvised from something like an aluminium plate, and this is also useful for getting light into any dark areas, such as when photographing plants in crevices.

Animals

Animals are another obvious subject for outdoor photography, including those on farms as well as the wild species.

Farm animals are relatively easy to photograph and horses in particular provide opportunities for attractive pictorial work. Since you can approach relatively closely in most cases, a normal lens should be quite adequate.

Wild animals are much more difficult to photograph effectively and the chief requirement is a long telephoto. Bird photography in particular is a highly-specialised craft requiring skill and patience. You need a telephoto of around 400mm on the 35mm format and a solid tripod to hold the whole thing steady. Otherwise, you need to construct a special hide.

If bird photography attracts you, but not enough for you to want to invest in expensive equipment, you might consider a camera incorporated into a pair of binoculars. These are usually only available in small format size — normally 110 — but they produce adequate results and the binoculars can also be used conventionally, so the weight penalty is minimised, especially if you plan to carry binoculars anyway.

Other wild animals such as deer and foxes are not normally visible during the day but you should be on the look-out for them at dawn as they return to their hides. Many animals will approach camp sites quite closely at this time of day, so a normal or moderate telephoto will give good results if you can react quickly enough.

Buildings

Buildings ought to be easy to photograph. For one thing, they don't move around! As with landscape work, however, the direction and angle of the light are critical and this needs to be taken into account when finding the best viewpoint.

The most common feature of architectural photography with cameras that are not designed especially for it is the converging vertical. If you tilt the camera backwards to include the whole building, the sides will converge, sometimes quite unnaturally.

To avoid converging verticals, you need to move back far enough so that the picture you want can be included on the film with the camera held parallel to the surface of the earth. This is not always possible since other buildings and obstructions may block the view. One solution is to use a wide angle lens. With this, you will be able to approach even closer if you turn the camera on its side for an upright picture (still keeping the film plane vertical). The subject will be off-set to one end of the negative but can be enlarged out later.

Moonlight

Shots by moonlight are more effective if the moon itself is included in the picture. To obtain some detail in the disc, the exposure time should be around one second, and this will make landscape forms appear as silhouettes. To illuminate the

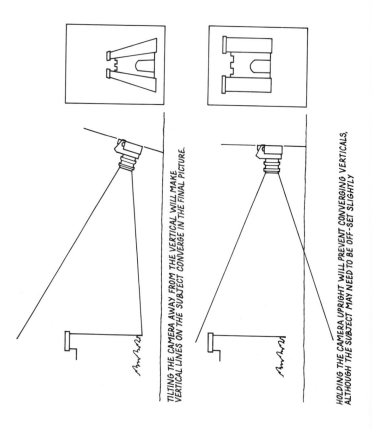

TILTING THE CAMERA AWAY FROM THE VERTICAL WILL MAKE
VERTICAL LINES ON THE SUBJECT CONVERGE IN THE FINAL PICTURE.

HOLDING THE CAMERA UPRIGHT WILL PREVENT CONVERGING VERTICALS,
ALTHOUGH THE SUBJECT MAY NEED TO BE OFF-SET SLIGHTLY

FIG. 15

landscape itself by moonlight you will need an exposure of several minutes and, if the moon's disc is in the field of view, it will appear as a burned-out highlight and slightly elongated as it moved across the sky during the exposure. Actual exposure times depend on local brightness and the speed of your film. If possible it is best to make several exposures of say 1 minute, 2 minutes and 6 minutes. The actual density of the image at long exposures can be surprisingly similar, since the sensitivity of film undergoes a change from normal at these sort of times. (For the technically-minded, this is known as the Reciprocity Effect.)

The apparent size of the moon on the negative will be larger and more dramatic if you use a telephoto: something around 100mm to 135mm on the 35mm format.

The most effective time of day for shots that include the moon is during the half-light, just before sunrise or just after sunset, when the light is not so bright as to obliterate the moon but just bright enough to give some colour to the sky and some outline to the landscape.

As part of an account of a camping trip, a shot of a group of tents by moonlight is very useful.

Lightning

Lightning can be photographed at any time of day but appears more dramatic at night or at dusk. The basic technique is to set your camera up on a firm rest and leave the shutter open for several minutes. This takes care of the problem of not being able to anticipate lightning and has the added interest of allowing you to collect several strikes on the same frame. Because you will be working at very low or non-existent ambient light levels, you can leave the shutter open at about f5.6 without any risk of over-exposure. Normally, the distant landscape will be illuminated, with foreground objects appearing in silhouette.

Needless to say, lightning should only be photographed when it is a safe distance away.

Artificial Light

You can, of course, take pictures of fellow-travellers at night by flash. This may be worthwhile if it is the only method

possible and you want to complete the record of a trip. It is best not to do this when people are busy outside, since it destroys night vision and can cause alarm to others quite a distance away if it is unexpected. Inside a tent or hut just before people settle down for the night is a good time for a couple of shots by flash. If the space is cramped, you can stop the lens right down and diffuse the brightness a little with a handkerchief in front of the flash window.

You can also use the light from gas, paraffin or petrol lamps to take camp site pictures. Exposures of about a quarter-second up to one second will be needed and this is one instance where you may have to ask people to hold still while you take the picture.

There will be some rapid fall-off in light away from the lamp but this just adds to the atmosphere. To avoid burned-out highlights at the light source, you should take a viewpoint where there is something between the light and the camera. A tent pole might suffice, if it is thick enough; or you can place someone's head in between to add a silhouette of a face to the picture.

Caves

Caves can be photographed by flash or by torchlight. Using flash, you set the camera up on a firm support with the shutter open and aimed at the scene you want to record. You then take the flash unit and move about, firing it by hand until you have illuminated the full area you want to cover. You have to keep the flash shielded from the camera by the odd convenient rock or stalactite or with your own body. In the last case, your own silhouette will appear on the frame — perhaps more than once — but this usually just makes the picture more interesting.

Another way of lighting a large area is by setting the camera up in the same way as for flash and then waving the beam from a torch backwards and forwards over the subject for a few minutes from behind the camera. This technique produces interesting results with other subjects, such as trees.

Floodlighting

Floodlit buildings such as castles and monuments make good subjects and are relatively easy to photograph. Long expos-

ures are necessary, so a tripod or some other support will be needed. It is important to position the camera so that the source of the individual floodlights does not appear in the picture as a bright point of white light to spoil the overall effect.

Exposure times for floodlighting will vary according to the intensity of the lamps and to how far away you are from the subject. For fairly close shots — up to about a hundred yards — try 1/60 second and 1/30. For distant buildings, try one minute, two minutes and five minutes. The most effective time of day is just after sunset, when there is still a little light in the sky. You should position yourself so that the exposure will not be ruined by things like car headlights. The odd person walking across the field of view should have no effect at long exposures. (Unless, of course, he or she is using a torch or smoking a cigarette!)

Chapter 9

PHOTOGRAPHIC EQUIPMENT

110 Cameras

Cameras for the 110 format produce a negative size of 11mm × 17mm. Most of them are very pocketable and easy to use. Film for 110 cameras is supplied in self-contained cartridges which you simply slip into the back. It is not possible to have accidental double exposures; the cartridge is shaped so that it cannot be inserted the wrong way round and you do not need to rewind at the end of the film.

The very small negative means that 110 film is really only practicable for postcard size enlargements from negatives, and this means colour negatives since 110 black-and-white film is not widely distributed. You can obtain transparency film in 110 but it is not suitable for projection beyond anything further than a few feet.

The first 110's were all very simple cameras and were intended for the casual snapshooter. Today, there are some very sophisticated models available. These seem to me to be going the way of the dinosaur. They have become so large that their original reason for existence has been forgotten. Some, indeed, are bigger than 35mm cameras, with the latter's much greater negative area.

If you really do only need postcard size prints, then the smaller type of 110 camera is the best choice. Because of their light weight, 110 cameras are prone to camera shake, so you should look for one that has a relatively fast shutter speed available: not less than 1/100 second. A very useful feature on some models is a built-in teleconverter which does not add appreciably to the size of the camera but which will extend your picture-making capability considerably. Some makes also have integral flash.

Colour negative film of 400ASA gives too-grainy results in 110 size, even at small enlargements, so where possible I would recommend the finer-grained 100ASA material.

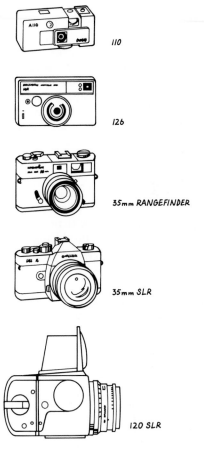

110

126

35mm RANGEFINDER

35mm SLR

120 SLR

FIG. 16

126 Cameras

Cameras in the 126 format also use cartridge film and are just as simple to operate as 110's. To a large extent, they have been displaced as a snapshooter's camera by the 110 and not many models are available. They do have the advantage of producing negatives 28mm square and this gives better print quality than 110. Transparency film is also available in 126 size and the picture area is large enough to permit projection over lecture-hall distances. At the moment, only one or two 126 cameras have controls that are advanced enough to permit the use of transparency film and none are available with interchangeable lenses (except for some discontinued types which occasionally appear on the second-hand market). This situation may change in the future, since the format is by no means redundant.

35mm Cameras

The 35mm format produces a negative size 24mm × 36mm. It is probably the most common film size in the world and more types of 35mm film are made than any other. 35mm cameras are versatile and capable of producing top quality results. The film has the added advantage for outdoor applications in that it comes in cassettes which hold up to 36 exposures per roll.

35mm Ultra-Compacts

This group includes the smallest full-frame 35mm cameras. Viewing is via a separate finder, sometimes with a built-in rangefinder coupled to the lens. Many have a sliding cover to protect the lens and viewfinder when not in use. Nearly all have built-in exposure meters linked to the aperture and shutter speed settings for fast operation. The majority have fixed lenses of a moderately wide angle but some are available with interchangeable lenses.

35mm Compacts

This range has the same features as the 35mm ultra-compacts but in a larger body, so they are somewhat cheaper. Many have a built-in flash unit. Some are fully automatic and a few feature automatic focusing also.

35mm Single Lens Reflexes

The 35mm single lens reflex (SLR) is the most advanced type of camera using this format.

Focusing is done through the actual taking lens by means of a mirror which diverts the image on to a screen in the view-finder and which flips out of the way of the film momentarily during exposure. This permits perfectly accurate focusing and composition, without any parallax error.

Almost all SLR's have interchangeable lenses. A few also have interchangeable viewfinders for specialist applications. Most of them also have meters that measure the light at full aperture and then close down automatically to the appropriate stop when making the exposure. This gives a brighter image and assists in faster, more accurate focusing. In conjunction with this facility, some SLR's have a preview device which allows you to close down to the selected stop before exposure to check the depth of field.

With *manual* metering, you adjust both aperture and shutter speed until the correct exposure is indicated: either by coloured lights or a moving needle.

Semi-automatic SLR's come in two varieties. In one, you set the aperture and the camera will set the correct shutter speed. This is known as the *aperture-priority* mode. Conversely, some cameras require you to set the shutter speed and the aperture is set automatically. This is the *shutter-priority* mode.

A third mode is *programmed automatic,* where the camera sets both the speed and the aperture. Many cameras of this type do not allow any sort of manual control (apart, of course, for the film speed setting) beyond an exposure over-ride facility for backlit situations.

Some 35mm cameras are *multi-mode* and allow a choice of any of the four types of operation.

Half-Frame Cameras

Half-frame cameras use normal 35mm film but produce a negative of 24mm × 18mm, so you can get 72 shots out of a single cassette. This has obvious advantages in travel photography. Very few cameras of this type are made today and most do not have interchangeable lenses. It is possible to buy high quality half-frame cameras that take interchangeable

lenses on the second-hand market and this format does have a considerable number of devotees. Unless the idea of having a lot of firepower appeals to you, a compact full-frame 35mm camera will be a better choice.

Rollfilm Cameras

Modern rollfilm cameras take 120 size film and most of them produce a negative 2¼" × 1¼", 2¼" × 2¾" or 2¼" × 3½".

Most rollfilm cameras made today are of the single lens reflex type, although the older twin lens reflex is still made and the traditional folding bellows type has also made a reappearance. They are expensive, slower to operate than 35mm cameras and more bulky.

If you have an old folding camera that is in good condition, that takes 120 and not 620 film, and is not too complicated to use, it will be worth considering for outdoor use because the

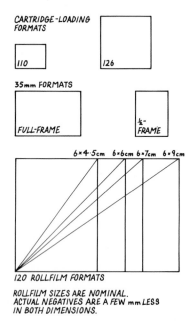

RELATIVE SIZES OF THE MORE POPULAR FILM FORMATS

CARTRIDGE-LOADING FORMATS

110

126

35mm FORMATS

FULL-FRAME

½-FRAME

6×4·5cm 6×6cm 6×7cm 6×9cm

120 ROLLFILM FORMATS

ROLLFILM SIZES ARE NOMINAL.
ACTUAL NEGATIVES ARE A FEW mm LESS
IN BOTH DIMENSIONS.

FIG. 17

great advantage of this type is that it is very compact when closed down. For accurate exposure, however, a separate meter will be needed.

Where to Start
If you are taking up photography for the first time, it will probably be better not to try anything too ambitious. Start off with a 110 or 126 and see how you get on with it for a few trips. If the results are encouraging and you want to increase your scope by buying a more versatile camera, your 110 or 126 will not be wasted, since you can carry it as a spare, for emergency use, or for photography in places where you might not want to risk a more expensive camera, such as the seaside.

Beyond the cartridge-loading formats, there is little that cannot be achieved by the full-frame 35mm camera. For about 90% of outdoor applications, a compact rangefinder, with lenses of 35mm, 50mm, and around 90mm will be more than adequate. If you venture into specialist areas, such as close-ups, you will need a single lens reflex. Whatever you buy, try to avoid models that become completely useless when the battery fails. These types use battery power for the shutter as well as the meter. Some of them will work mechanically on just one speed when the battery has failed.

Special Cameras
If you are an all-weather outdoors person, there are some special cameras available that will allow you to go on shooting in the worst of weather. These types are intended for underwater use without the need for special housings. This group includes the 35mm Nikonos 4, which has interchangeable lenses, and the 110 Minolta Weathermatic.

Accessories
Even though weight and bulk need to be kept to a minimum in outdoor photography, there are a few accessories which are essential.

A *lens hood* prevents image degradation by shielding the lens from extraneous light. It also provides some useful physical protection.

A *haze or ultra-violet filter* will eliminate the slight haze from distant views and any blueness from shadow areas in colour photography and will also protect the lens.

A *pale yellow or yellow-green filter* will prevent blue sky and clouds from merging into a single pale shade if you are shooting black-and-white film.

A small *blower brush* will be useful for cleaning any dust from lenses and camera film chambers.

A *tripod* is useful if you want to include yourself in group shots or if you want to compose a picture and then wait for some change in the lighting before you take the picture. Using a tripod means you don't have to stand with the camera held to your eye all the time.

Tripods are also valuable in panorama work and you can also use one to make a frame for a hide, or temporary shelter from rain.

Experts advise that you should use substantial tripods but these are not really viable for outdoor trips. A lightweight model will be perfectly adequate if you are using fast enough shutter speeds.

Alternatives to a full-size tripod are table-top models, or those fitted with ball-and-socket heads attached to G-clamps, mole wrenches, walking stick heads or ice axes.

Flash. A small flash is useful for the types of photography described in connection with portraiture, interior shots and close-ups. Theoretically, it could also serve as a useful signalling device if you ever end up in a difficult situation and need to attract the attention of rescuers, although I have not heard of it being used for this purpose yet.

Spares. If your camera uses batteries, always take along a spare set.

FURTHER READING

If you wish to learn more about photography, there is a vast amount of material available in the form of monthly and weekly magazines and books.

Naturally enough, some are better than others, and the more expensive and lavishly illustrated books are not necessarily the most helpful.

The Focal Press produces a large number of Guides to various aspects of photography and these are all relatively inexpensive and good value for money.

Alternatively, your local library should be well-supplied with appropriate material.

Climber

& rambler

Britain's leading outdoor adventure magazine and the journal of the British Mountaineering Council

Holmes McDougall Publications